To one of Santa's favorites,

from___ _____

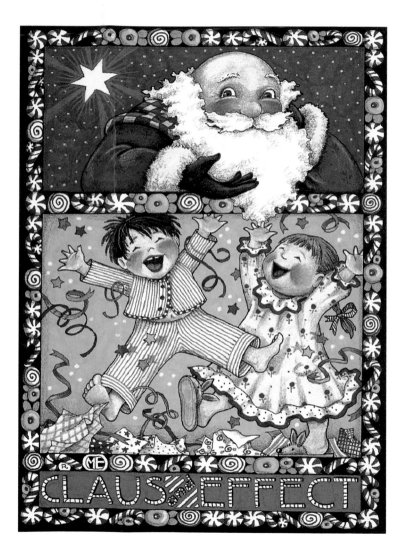

CLAUS and EFFECT

Claus and Effect

Illustrated by
Mary Engelbreit

**Andrews McMeel
Publishing**

Kansas City

is a registered trademark of Mary Engelbreit
 Enterprises, Inc.

ISBN: 0-8362-3677-7

Written by Jan Miller Girando

Claus and Effect

Is there really a Santa?
There must be! Of course!
If there's not, how do presents and toys
get delivered each year
by eight tiny reindeer
to the homes of all good girls and boys?

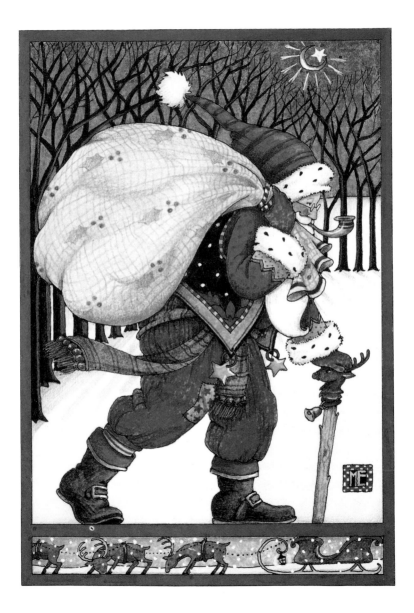

The traditional tale
of the night before Christmas
says Santa piles gifts in his sleigh
and takes off through the snow
with a grand "Ho, Ho, Ho!"
to deliver the goodies our way!

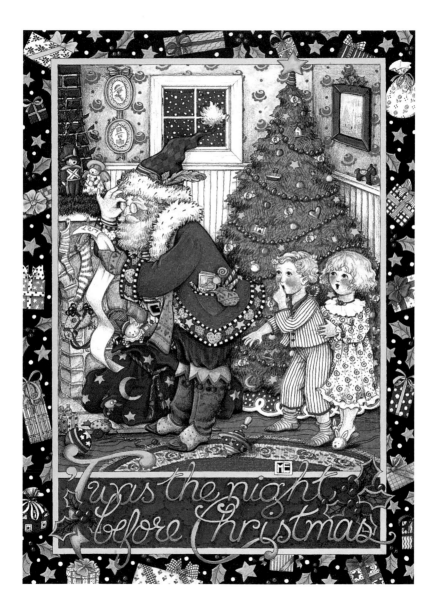

'Twas the night before Christmas

And no matter how big
or how little we are,
when we slip into bed Christmas Eve,
we all want to think Santa
is heading our way—
we're all trying our best to believe!

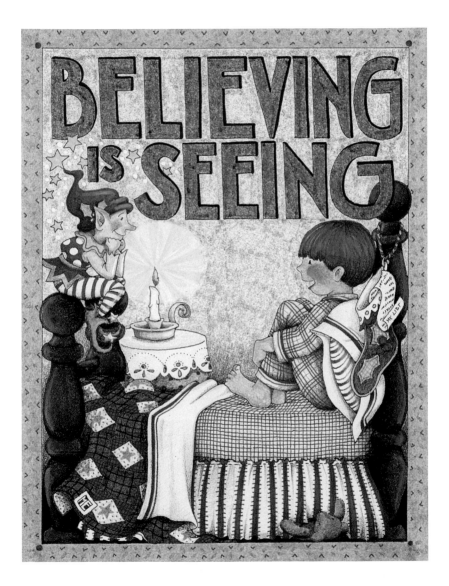

As we close our eyes tight
and start drifting to dreamland,
we want to imagine we hear
the mysterious jingling
of faraway sleigh bells—
a sign Santa soon will appear!

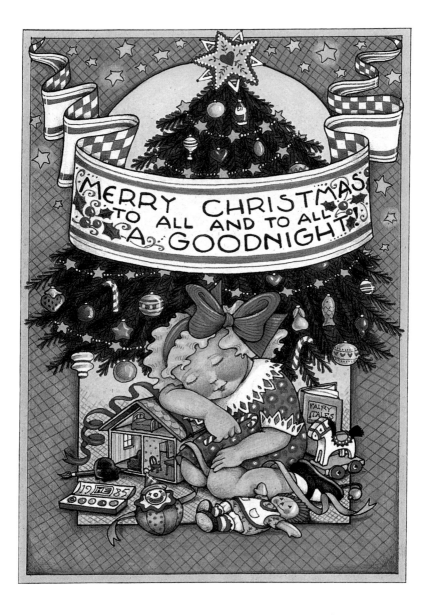

Is there really a list
of who's naughty and nice
that's compiled by our merry old friend?

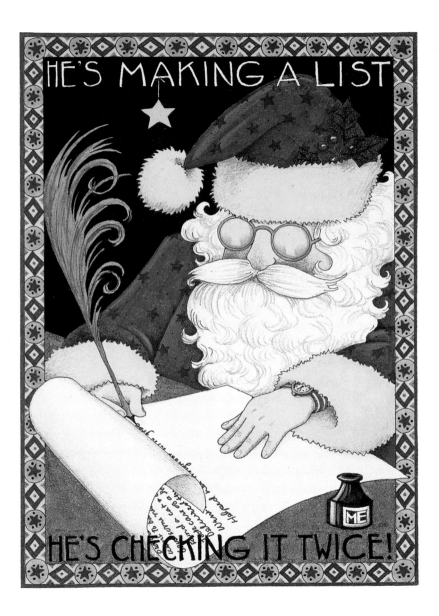

Have we made all this up?
Is there really a Santa
or is the whole story pretend?

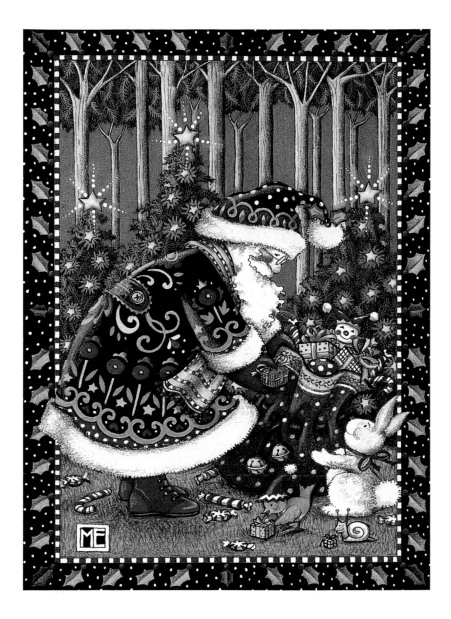

If there wasn't a Santa,
would children's eyes sparkle
the way that they do when they see
all the special surprises
of all shapes and sizes
awaiting them under the tree?

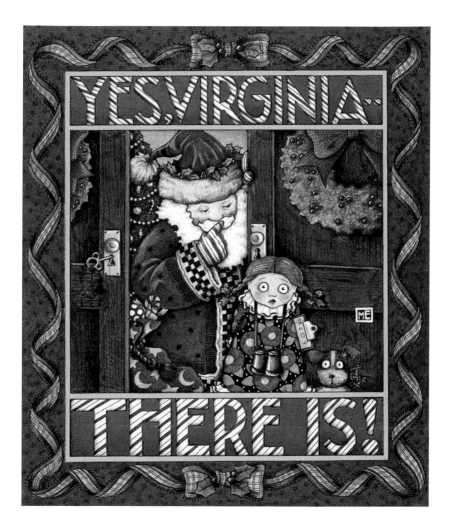

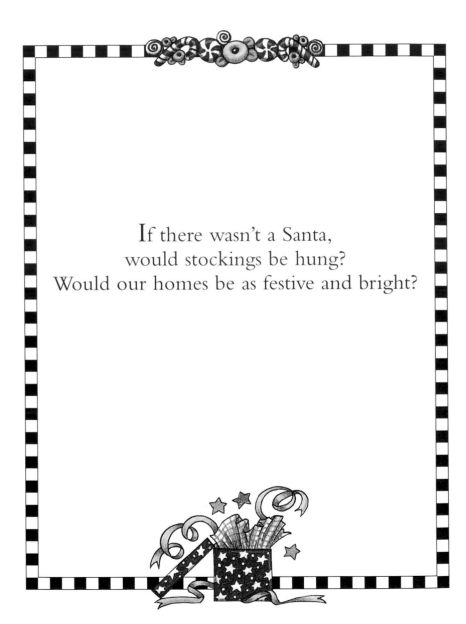

If there wasn't a Santa,
would stockings be hung?
Would our homes be as festive and bright?

Would the mistletoe, holly,
and bows be so jolly?
Would loved ones be such a delight?

If there wasn't a Santa,
would Christmastime feasts
be as full of good food and good cheer?
Would the grown-ups be children
again for a while
and would troubles somehow disappear?

There is surely a reason
for holiday hoopla—
a reason the halls are bedecked—
there is surely somebody
behind all of this—
a cause for this Christmas effect!

AN INTIMATE VIEW of CHRISTMAS

As we hear far away,
"Merry Christmas to All,"
glimpse a sleigh dashing
into the night…

…we are smugly amused,
for the riddle's been solved—
there is really a Santa Claus! Right??

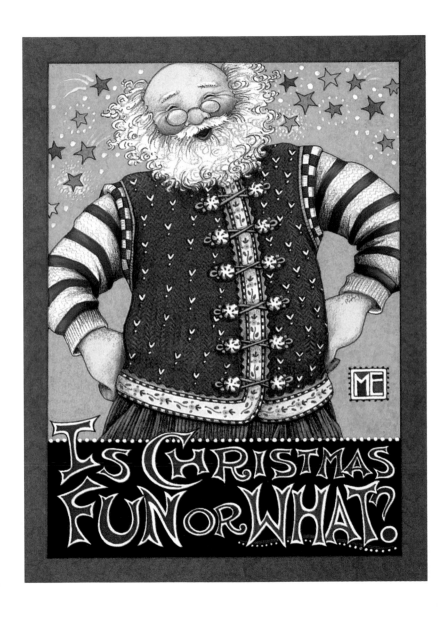

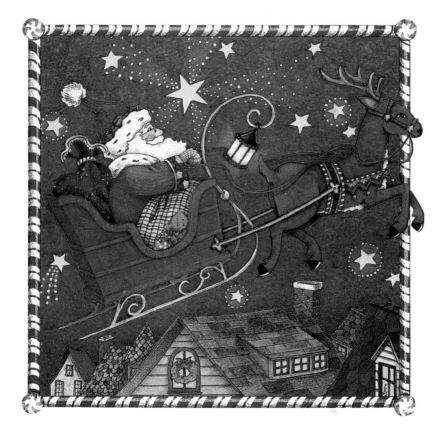